PENGUIN BOOKS

CITIZEN

'Claudia Rankine's . . . achievement is to have created a bold work that occupies its own space powerfully, an unsettled hybrid . . . There is so much anger and anguish here that you wonder how it can be contained. But what is wonderful about Rankine's writing is that it works like an out-of-body experience: she encounters her subject full-on and rises above it. And she never loses her wide-angle reach'
Kate Kellaway, *Observer*, Poetry Book of the Month

'*Citizen* is one of the most brilliant pieces of writing that will appear in the UK this year . . . This is a book that is both hard to read and hard to stop reading . . . In *Citizen*, Rankine has written a great American poem on her own terms . . . this is the book of a generation' Jeremy Noel-Tod, *Sunday Times*

'*Citizen* is about the desolation created by internalised racist assumptions – the careless word, the telling error, the failure to see clearly or to admit to what is the case. It is also about the violent continuity between the lynchings of the past and the current readiness of the police to kill black men . . . Rankine draws on both her own and others' experience . . . to show prejudice working all the way up the economic ladder . . . [She] works by impeccable timing . . . with an even tone enforcing an implacable verbal economy and exactitude. This is what it's like, she says. It's hard to disagree'
Sean O'Brien, *Independent*

'An especially vital book for this moment in time . . . The realization at the end of this book sits heavily upon the heart: "This is how you are a citizen," Rankine writes. "Come on. Let it go. Move on." As Rankine's brilliant, disabusing work, always aware of its ironies, reminds us, "moving on" is not synonymous with "leaving behind."'
Dan Chiasson, *New Yorker*

'To be black, *Citizen* insists, is to be audibly, palpably, invisible, and the book is in large part a struggle to make that feeling tangible . . . Genius'
Jonathan Farmer, *Slate*

'Wonderfully capacious and innovative. In her riffs on the demotic, in her layering of incident, Rankine finds a new way of writing about race in America' Nick Laird, *New York Review of Books*

'Rankine brilliantly pushes poetry's forms . . . one is left with a mix of emotions that linger and wend themselves into the subconscious' Holly Bass, *The New York Times*

ABOUT THE AUTHOR

Claudia Rankine is the author of four previous books, including *Don't Let Me Be Lonely: An American Lyric*. A chancellor of the Academy of American Poets, she is the winner of the Jackson Poetry Prize and, for *Citizen*, the National Book Critics Circle Award for Poetry, the *Los Angeles Times* Book Prize for Poetry, the PEN Open Book Award and an NAACP Award for Outstanding Literary Work. She teaches at the University of Southern California, where she holds the Aerol Arnold Chair of English.

CITIZEN

An American Lyric

Claudia Rankine

PENGUIN BOOKS

PENGUIN BOOKS

UK | USA | Canada | Ireland | Australia
India | New Zealand | South Africa

Penguin Books is part of the Penguin Random House group of companies whose
addresses can be found at global.penguinrandomhouse.com.

First published in the United States of America by Graywolf Press 2014
Published in Penguin Books 2015
002

Permissions acknowledgements appear on pp 163–164

Printed in Italy by Printer Trento Srl

A CIP catalogue record for this book is available from the British Library

ISBN: 978-0-141-98177-2

www.greenpenguin.co.uk

MIX
Paper from
responsible sources
FSC
www.fsc.org FSC® C018179

Penguin Random House is committed to a
sustainable future for our business, our
readers and our planet. This book is made
from Forest Stewardship Council® certified

If they don't see happiness in the picture,
at least they'll see the black.

Chris Marker, *Sans Soleil*

For

Donovan Harris
Charles Kelly
Frankie Porter
Richard Roderick

CITIZEN

I

When you are alone and too tired even to turn on any of your devices, you let yourself linger in a past stacked among your pillows. Usually you are nestled under blankets and the house is empty. Sometimes the moon is missing and beyond the windows the low, gray ceiling seems approachable. Its dark light dims in degrees depending on the density of clouds and you fall back into that which gets reconstructed as metaphor.

The route is often associative. You smell good. You are twelve attending Sts. Philip and James School on White Plains Road and the girl sitting in the seat behind asks you to lean to the right during exams so she can copy what you have written. Sister Evelyn is in the habit of taping the 100s and the failing grades to the coat closet doors. The girl is Catholic with waist-length brown hair. You can't remember her name: Mary? Catherine?

You never really speak except for the time she makes her request and later when she tells you you smell good and have features more like a white person. You assume she thinks she is thanking you for letting her cheat and feels better cheating from an almost white person.

Sister Evelyn never figures out your arrangement perhaps because you never turn around to copy Mary Catherine's answers. Sister Evelyn must think these two girls think a lot alike or she cares less about cheating and more about humiliation or she never actually saw you sitting there.

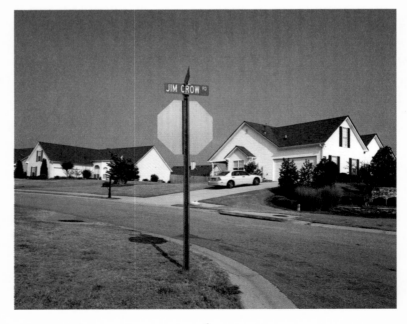

Certain moments send adrenaline to the heart, dry out the tongue, and clog the lungs. Like thunder they drown you in sound, no, like lightning they strike you across the larynx. Cough. After it happened I was at a loss for words. Haven't you said this yourself? Haven't you said this to a close friend who early in your friendship, when distracted, would call you by the name of her black housekeeper? You assumed you two were the only black people in her life. Eventually she stopped doing this, though she never acknowledged her slippage. And you never called her on it (why not?) and yet, you don't forget. If this were a domestic tragedy, and it might well be, this would be your fatal flaw—your memory, vessel of your feelings. Do you feel hurt because it's the "all black people look the same" moment, or because you are being confused with another after being so close to this other?

An unsettled feeling keeps the body front and center. The wrong words enter your day like a bad egg in your mouth and puke runs down your blouse, a dampness drawing your stomach in toward your rib cage. When you look around only you remain. Your own disgust at what you smell, what you feel, doesn't bring you to your feet, not right away, because gathering energy has become its own task, needing its own argument. You are reminded of a conversation you had recently, comparing the merits of sentences constructed implicitly with "yes, and" rather than "yes, but." You and your friend decided that "yes, and" attested to a life with no turn-off, no alternative routes: you pull yourself to standing, soon enough the blouse is rinsed, it's another week, the blouse is beneath your sweater, against your skin, and you smell good.

The rain this morning pours from the gutters and everywhere else it is lost in the trees. You need your glasses to single out what you know is there because doubt is inexorable; you put on your glasses. The trees, their bark, their leaves, even the dead ones, are more vibrant wet. Yes, and it's raining. Each moment is like this—before it can be known, categorized as similar to another thing and dismissed, it has to be experienced, it has to be seen. What did he just say? Did she really just say that? Did I hear what I think I heard? Did that just come out of my mouth, his mouth, your mouth? The moment stinks. Still you want to stop looking at the trees. You want to walk out and stand among them. And as light as the rain seems, it still rains down on you.

You are in the dark, in the car, watching the black-tarred street being swallowed by speed; he tells you his dean is making him hire a person of color when there are so many great writers out there.

· You think maybe this is an experiment and you are being tested or retroactively insulted or you have done something that communicates this is an okay conversation to be having.

Why do you feel comfortable saying this to me? You wish the light would turn red or a police siren would go off so you could slam on the brakes, slam into the car ahead of you, fly forward so quickly both your faces would suddenly be exposed to the wind.

As usual you drive straight through the moment with the expected backing off of what was previously said. It is not only that confrontation is headache-producing; it is also that you have a destination that doesn't include acting like this moment isn't inhabitable, hasn't happened before, and the before isn't part of the now as the night darkens and the time shortens between where we are and where we are going.

When you arrive in your driveway and turn off the car, you remain behind the wheel another ten minutes. You fear the night is being locked in and coded on a cellular level and want time to function as a power wash. Sitting there staring at the closed garage door you are reminded that a friend once told you there exists the medical term—John Henryism—for people exposed to stresses stemming from racism. They achieve themselves to death trying to dodge the buildup of erasure. Sherman James, the researcher who came up with the term, claimed the physiological costs were high. You hope by sitting in silence you are bucking the trend.

Because of your elite status from a year's worth of travel, you have already settled into your window seat on United Airlines, when the girl and her mother arrive at your row. The girl, looking over at you, tells her mother, these are our seats, but this is not what I expected. The mother's response is barely audible—I see, she says. I'll sit in the middle.

A woman you do not know wants to join you for lunch. You are visiting her campus. In the café you both order the Caesar salad. This overlap is not the beginning of anything because she immediately points out that she, her father, her grandfather, and you, all attended the same college. She wanted her son to go there as well, but because of affirmative action or minority something—she is not sure what they are calling it these days and weren't they supposed to get rid of it?—her son wasn't accepted. You are not sure if you are meant to apologize for this failure of your alma mater's legacy program; instead you ask where he ended up. The prestigious school she mentions doesn't seem to assuage her irritation. This exchange, in effect, ends your lunch. The salads arrive.

A friend argues that Americans battle between the "historical self" and the "self self." By this she means you mostly interact as friends with mutual interest and, for the most part, compatible personalities; however, sometimes your historical selves, her white self and your black self, or your white self and her black self, arrive with the full force of your American positioning. Then you are standing face-to-face in seconds that wipe the affable smiles right from your mouths. What did you say? Instantaneously your attachment seems fragile, tenuous, subject to any transgression of your historical self. And though your joined personal histories are supposed to save you from misunderstandings, they usually cause you to understand all too well what is meant.

You and your partner go to see the film *The House We Live In.* You ask a friend to pick up your child from school. On your way home your phone rings. Your neighbor tells you he is standing at his window watching a menacing black guy casing both your homes. The guy is walking back and forth talking to himself and seems disturbed.

You tell your neighbor that your friend, whom he has met, is babysitting. He says, no, it's not him. He's met your friend and this isn't that nice young man. Anyway, he wants you to know, he's called the police.

Your partner calls your friend and asks him if there's a guy walking back and forth in front of your home. Your friend says that if anyone were outside he would see him because he is standing outside. You hear the sirens through the speakerphone.

Your friend is speaking to your neighbor when you arrive home. The four police cars are gone. Your neighbor has apologized to your friend and is now apologizing to you. Feeling somewhat responsible for the actions of your neighbor, you clumsily tell your friend that the next time he wants to talk on the phone he should just go in the backyard. He looks at you a long minute before saying he can speak on the phone wherever he wants. Yes, of course, you say. Yes, of course.

When the stranger asks, Why do you care? you just stand there staring at him. He has just referred to the boisterous teenagers in Starbucks as niggers. Hey, I am standing right here, you responded, not necessarily expecting him to turn to you.

He is holding the lidded paper cup in one hand and a small paper bag in the other. They are just being kids. Come on, no need to get all KKK on them, you say.

Now there you go, he responds.

The people around you have turned away from their screens. The teenagers are on pause. There I go? you ask, feeling irritation begin to rain down. Yes, and something about hearing yourself repeating this stranger's accusation in a voice usually reserved for your partner makes you smile.

A man knocked over her son in the subway. You feel your own body wince. He's okay, but the son of a bitch kept walking. She says she grabbed the stranger's arm and told him to apologize: I told him to look at the boy and apologize. Yes, and you want it to stop, you want the child pushed to the ground to be seen, to be helped to his feet, to be brushed off by the person that did not see him, has never seen him, has perhaps never seen anyone who is not a reflection of himself.

The beautiful thing is that a group of men began to stand behind me like a fleet of bodyguards, she says, like newly found uncles and brothers.

The new therapist specializes in trauma counseling. You have only ever spoken on the phone. Her house has a side gate that leads to a back entrance she uses for patients. You walk down a path bordered on both sides with deer grass and rosemary to the gate, which turns out to be locked.

At the front door the bell is a small round disc that you press firmly. When the door finally opens, the woman standing there yells, at the top of her lungs, Get away from my house! What are you doing in my yard?

It's as if a wounded Doberman pinscher or a German shepherd has gained the power of speech. And though you back up a few steps, you manage to tell her you have an appointment. You have an appointment? she spits back. Then she pauses. Everything pauses. Oh, she says, followed by, oh, yes, that's right. I am sorry.

I am so sorry, so, so sorry.

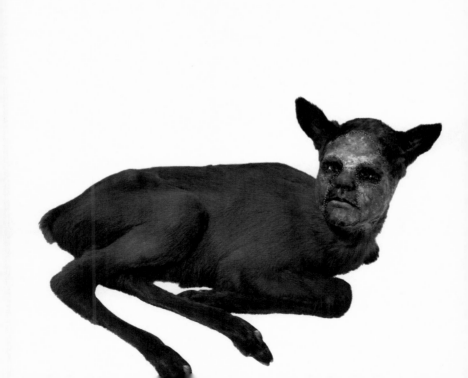

II

Hennessy Youngman aka Jayson Musson, whose *Art Thoughtz* take the form of tutorials on YouTube, educates viewers on contemporary art issues. In one of his many videos, he addresses how to become a successful black artist, wryly suggesting black people's anger is marketable. He advises black artists to cultivate "an angry nigger exterior" by watching, among other things, the Rodney King video while working.

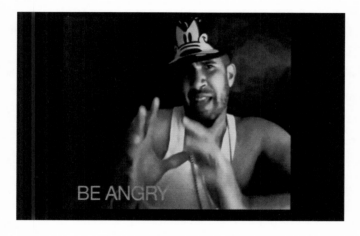

Youngman's suggestions are meant to expose expectations for blackness as well as to underscore the difficulty inherent in any attempt by black artists to metabolize real rage. The commodified anger his video advocates rests lightly on the surface for spectacle's sake. It can be engaged or played like the race card and is tied solely to the performance of blackness and not to the emotional state of particular individuals in particular situations.

On the bridge between this sellable anger and "the artist" resides, at times, an actual anger. Youngman in his video doesn't address this type of anger: the anger built up through experience and the quotidian struggles against dehumanization every brown or black person lives simply because of skin color. This other kind of anger in time can prevent, rather than sponsor, the production of anything except loneliness.

You begin to think, maybe erroneously, that this other kind of anger is really a type of knowledge: the type that both clarifies and disappoints. It responds to insult and attempted erasure simply by asserting presence, and the energy required to present, to react, to assert is accompanied by visceral disappointment: a disappointment in the sense that no amount of visibility will alter the ways in which one is perceived.

Recognition of this lack might break you apart. Or recognition might illuminate the erasure the attempted erasure triggers. Whether such discerning creates a healthier, if more isolated, self, you can't know. In any case, Youngman doesn't speak to this kind of anger. He doesn't say that witnessing the expression of this more ordinary and daily anger might make the witness believe that a person is "insane."

And insane is what you think, one Sunday afternoon, drinking an Arnold Palmer, watching the 2009 Women's US Open semi-final, when brought to full attention by the suddenly explosive behavior of Serena Williams. Serena in HD before your eyes becomes overcome by a rage you recognize and have been taught to hold at a distance for your own good. Serena's behavior, on this particular Sunday afternoon, suggests that all the injustice she has played through all the years of her illustrious career flashes before her and she decides finally to respond to all of it with a string of invectives. Nothing, not even the repetition of negations ("no, no, no") she employed in a similar situation years before as a younger player at the 2004 US Open, prepares you for this. Oh my God, she's gone crazy, you say to no one.

What does a victorious or defeated black woman's body in a historically white space look like? Serena and her big sister Venus Williams brought to mind Zora Neale Hurston's "I feel most colored when I am thrown against a sharp white background." This appropriated line, stenciled on canvas by Glenn Ligon, who used plastic letter stencils, smudging oil sticks, and graphite to transform the words into abstractions, seemed to be ad copy for some aspect of life for all black bodies.

Hurston's statement has been played out on the big screen by Serena and Venus: they win sometimes, they lose sometimes, they've been injured, they've been happy, they've been sad, ignored, booed mightily (see Indian Wells, which both sisters have boycotted for more than a decade), they've been cheered, and through it all and evident to all were those people who are enraged they are there at all—graphite against a sharp white background.

For years you attribute to Serena Williams a kind of resilience appropriate only for those who exist in celluloid. Neither her father nor her mother nor her sister nor Jehovah her God nor NIKE camp could shield her ultimately from people who felt her black body didn't belong on their court, in their world. From the start many made it clear Serena would have done better struggling to survive in the two-dimensionality of a Millet painting, rather than on their tennis court—better to put all that strength to work in their fantasy of her working the land, rather than be caught up in the turbulence of our ancient dramas, like a ship fighting a storm in a Turner seascape.

The most notorious of Serena's detractors takes the form of Mariana Alves, the distinguished tennis chair umpire. In 2004 Alves was excused from officiating any more matches on the final day of the US Open after she made five bad calls against Serena in her quarter-final matchup against

fellow American Jennifer Capriati. The serves and returns Alves called out were landing, stunningly unreturned by Capriati, inside the lines, no discerning eyesight needed. Commentators, spectators, television viewers, line judges, everyone could see the balls were good, everyone, apparently, except Alves. No one could understand what was happening. Serena, in her denim skirt, black sneaker boots, and dark mascara, began wagging her finger and saying "no, no, no," as if by negating the moment she could propel us back into a legible world. Tennis superstar John McEnroe, given his own keen eye for injustice during his professional career, was shocked that Serena was able to hold it together after losing the match.

Though no one was saying anything explicitly about Serena's black body, you are not the only viewer who thought it was getting in the way of Alves's sight line. One commentator said he hoped he wasn't being unkind when he stated, "Capriati wins it with the help of the umpires and the lines judges." A year later that match would be credited for demonstrating the need for the speedy installation of Hawk-Eye, the line-calling technology that took the seeing away from the beholder. Now the umpire's call can be challenged by a replay; however, back then after the match Serena said, "I'm very angry and bitter right now. I felt cheated. Shall I go on? I just feel robbed." And though you felt outrage for Serena after that 2004 US Open, as the years go by, she

seems to put Alves, and a lengthening list of other curious calls and oversights, against both her and her sister, behind her as they happen.

Yes, and the body has memory. The physical carriage hauls more than its weight. The body is the threshold across which each objectionable call passes into consciousness—all the unintimidated, unblinking, and unflappable resilience does not erase the moments lived through, even as we are eternally stupid or everlastingly optimistic, so ready to be inside, among, a part of the games.

And here Serena is, five years after Alves, back at the US Open, again in a semi-final match, this time against Belgium's Kim Clijsters. Serena is not playing well and loses the first set. In response she smashes her racket on the court. Now McEnroe isn't stunned by her ability to hold herself together and is moved to say, "That's as angry as I've ever seen her." The umpire gives her a warning; another violation will mean a point penalty.

She is in the second set at the critical moment of 5-6 in Clijsters's favor, serving to stay in the match, at match point. The line judge employed by the US Open to watch Serena's body, its every move, says Serena stepped on the line while serving. What? (The Hawk-Eye cameras don't cover the feet, only the ball, apparently.) What! Are you

serious? She is serious; she has seen a foot fault, one no one else is able to locate despite the numerous replays. "No foot fault, you definitely do not see a foot fault there," says McEnroe. "That's overofficiating for certain," says another commentator. Even the ESPN tennis commentator, who seems predictable in her readiness to find fault with the Williams sisters, says, "Her foot fault call was way off." Yes, and even if there had been a foot fault, despite the rule, they are rarely ever called at critical moments in a Grand Slam match because "You don't make a call," tennis official Carol Cox says, "that can decide a match unless it's flagrant."

As you look at the affable Kim Clijsters, you try to entertain the thought that this scenario could have played itself out the other way. And as Serena turns to the lineswoman and says, "I swear to God I'm fucking going to take this fucking ball and shove it down your fucking throat, you hear that? I swear to God!" As offensive as her outburst is, it is difficult not to applaud her for reacting immediately to being thrown against a sharp white background. It is difficult not to applaud her for existing in the moment, for fighting crazily against the so-called wrongness of her body's positioning at the service line.

She says in 2009, belatedly, the words that should have been said to the umpire in 2004, the words that might have snapped Alves back into focus, a focus that would have acknowledged what actually was happening on the court. Now Serena's reaction is read as insane. And her punishment for this moment of manumission is the threatened point penalty resulting in the loss of the match, an $82,500 fine, plus a two-year probationary period by the Grand Slam Committee.

Perhaps the committee's decision is only about context, though context is not meaning. It is a public event being watched in homes across the world. In any case, it is difficult not to think that if Serena lost context by abandoning all rules of civility, it could be because her body, trapped in a racial imaginary, trapped in disbelief—code for being black in America—is being governed not by the tennis match she is participating in but by a collapsed relationship that had promised to play by the rules. Perhaps this is how racism feels no matter the context—randomly the rules everyone else gets to play by no longer apply to you, and to call this out by calling out "I swear to God!" is to be called insane, crass, crazy. Bad sportsmanship.

Two years later, September 11, 2011, Serena is playing the Australian Sam Stosur in the US Open final. She is expected to win, having just beaten the number-one player, the Dane

Caroline Wozniacki, in the semi-final the night before. Some speculate Serena especially wants to win this Grand Slam because it is the tenth anniversary of the attack on the Twin Towers. It's believed that by winning she will prove her red-blooded American patriotism and will once and for all become beloved by the tennis world (think Arthur Ashe after his death). All the bad calls, the boos, the criticisms that she has made ugly the game of tennis—through her looks as well as her behavior—that entire cluster of betrayals will be wiped clean with this win.

One imagines her wanting to say what her sister would say a year later after being diagnosed with Sjögren's syndrome and losing her match to shouts of "Let's go, Venus!" in Arthur Ashe Stadium: "I know this is not proper tennis etiquette, but this is the first time I've ever played here that the crowd has been behind me like that. Today I felt American, you know, for the first time at the US Open. So I've waited my whole career to have this moment and here it is."

It is all too exhausting and Serena's exhaustion shows in her playing; she is losing, a set and a game down. Yes, and finally she hits a great shot, a big forehand, and before the ball is safely past Sam Stosur's hitting zone, Serena yells, "Come on!" thinking she has hit an irretrievable winner. The umpire, Eva Asderaki, rules correctly that Serena,

by shouting, interfered with Stosur's concentration. Subsequently, a ball that Stosur seemingly would not have been able to return becomes Stosur's point. Serena's reply is to ask the umpire if she is trying to screw her again. She remembers the umpire doing this to her before. As a viewer, you too, along with John McEnroe, begin to wonder if this is the same umpire from 2004 or 2009. It isn't—in 2004 it was Mariana Alves and in 2009 it was Sharon Wright; however, the use of the word "again" by Serena returns her viewers to other times calling her body out.

Again Serena's frustrations, her disappointments, exist within a system you understand not to try to understand in any fair-minded way because to do so is to understand the erasure of the self as systemic, as ordinary. For Serena, the daily diminishment is a low flame, a constant drip. Every look, every comment, every bad call blossoms out of history, through her, onto you. To understand is to see Serena as hemmed in as any other black body thrown against our American background. "Aren't you the one that screwed me over last time here?" she asks umpire Asderaki. "Yeah, you are. Don't look at me. Really, don't even look at me. Don't look my way. Don't look my way," she repeats, because it is that simple.

Yes, and who can turn away? Serena is not running out of breath. Despite all her understanding, she continues to

serve up aces while smashing rackets and fraying hems. In the 2012 Olympics she brought home two of the three gold medals the Americans would win in tennis. After her three-second celebratory dance on center court at the All England Club, the American media reported, "And there was Serena . . . Crip-Walking all over the most lily-white place in the world. . . . You couldn't help but shake your head. . . . What Serena did was akin to cracking a tasteless, X-rated joke inside a church. . . . What she did was immature and classless."

Before making the video *How to Be a Successful Black Artist,* Hennessy Youngman uploaded to YouTube *How to Be a Successful Artist.* While putting forward the argument that one needs to be white to be truly successful, he adds, in an aside, that this might not work for blacks because if "a nigger paints a flower it becomes a slavery flower, flower de *Amistad,*" thereby intimating that any relationship between the white viewer and the black artist immediately becomes one between white persons and black property, which was the legal state of things once upon a time, as Patricia Williams has pointed out in *The Alchemy of Race and Rights*: "The cold game of equality staring makes me feel like a thin sheet of glass. . . . I could force my presence, the real me contained in those eyes, upon them, but I would be smashed in the process."

Interviewed by the Brit Piers Morgan after her 2012 Olympic victory, Serena is informed by Morgan that he was planning on calling her victory dance "the Serena Shuffle"; however, he has learned from the American press that it is a Crip Walk, a gangster dance. Serena responds incredulously by asking if she looks like a gangster to him. Yes, he answers. All in a day's fun, perhaps, and in spite and despite it all, Serena Williams blossoms again into Serena Williams. When asked if she is confident she can win her upcoming matches, her answer remains, "At the end of the day, I am very happy with me and I'm very happy with my results."

Serena would go on to win every match she played between the US Open and the year-end 2012 championship tournament, and because tennis is a game of adjustments, she would do this without any reaction to a number of questionable calls. More than one commentator would remark on her ability to hold it together during these matches. She is a woman in love, one suggests. She has grown up, another decides, as if responding to the injustice of racism is childish and her previous demonstration of emotion was free-floating and detached from any external actions by others. Some others theorize she is developing the admirable "calm and measured logic" of an Arthur Ashe, who the sportswriter Bruce Jenkins felt was "dignified" and "courageous" in his ability to confront injustice without making a scene. Jenkins, perhaps inspired by Serena's new comportment, felt moved to argue that her continued boycott of Indian Wells in 2013, where she felt traumatized by the aggression of racist slurs hurled at her in 2001, was lacking in "dignity" and "integrity" and demonstrated "only stubbornness and a grudge."

Watching this newly contained Serena, you begin to wonder if she finally has given up wanting better from her peers or if she too has come across Hennessy's *Art Thoughtz* and is channeling his assertion that the less that is communicated the better. Be ambiguous. This type of ambiguity could also be diagnosed as dissociation and would support Serena's

claim that she has had to split herself off from herself and create different personae.

Now that there is no calling out of injustice, no yelling, no cursing, no finger wagging or head shaking, the media decides to take up the mantle when on December 12, 2012, two weeks after Serena is named WTA Player of the Year, the Dane Caroline Wozniacki, a former number-one player, imitates Serena by stuffing towels in her top and shorts, all in good fun, at an exhibition match. Racist? CNN wants to know if outrage is the proper response.

It's then that Hennessy's suggestions about "how to be a successful artist" return to you: be ambiguous, be white. Wozniacki, it becomes clear, has finally enacted what was desired by many of Serena's detractors, consciously or unconsciously, the moment the Compton girl first stepped on court. Wozniacki (though there are a number of ways to interpret her actions—playful mocking of a peer, imitation of the mimicking antics of the tennis player known as the joker, Novak Djokovic) finally gives the people what they have wanted all along by embodying Serena's attributes while leaving Serena's "angry nigger exterior" behind. At last, in this real, and unreal, moment, we have Wozniacki's image of smiling blond goodness posing as the best female tennis player of all time.

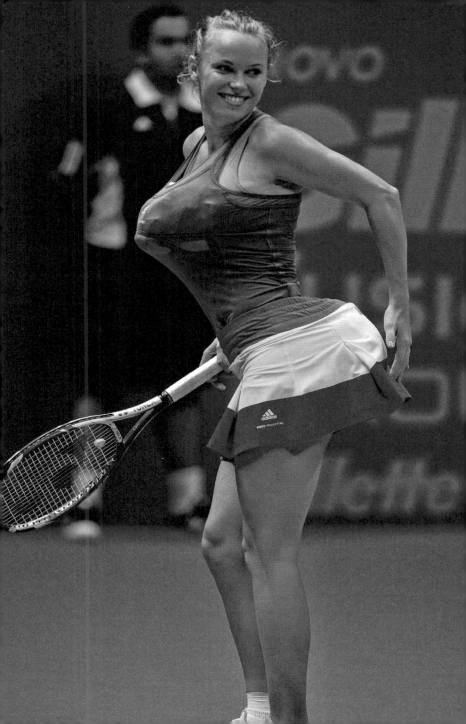

III

You are rushing to meet a friend in a distant neighborhood of Santa Monica. This friend says, as you walk toward her, You are late, you nappy-headed ho. What did you say? you ask, though you have heard every word. This person has never before referred to you like this in your presence, never before code-switched in this manner. What did you say? She doesn't, perhaps physically cannot, repeat what she has just said.

Maybe the content of her statement is irrelevant and she only means to signal the stereotype of "black people time" by employing what she perceives to be "black people language." Maybe she is jealous of whoever kept you and wants to suggest you are nothing or everything to her. Maybe she wants to have a belated conversation about Don Imus and

the women's basketball team he insulted with this language. You don't know. You don't know what she means. You don't know what response she expects from you nor do you care. For all your previous understandings, suddenly incoherence feels violent. You both experience this cut, which she keeps insisting is a joke, a joke stuck in her throat, and like any other injury, you watch it rupture along its suddenly exposed suture.

When a woman you work with calls you by the name of another woman you work with, it is too much of a cliché not to laugh out loud with the friend beside you who says, oh no she didn't. Still, in the end, so what, who cares? She had a fifty-fifty chance of getting it right.

Yes, and in your mail the apology note appears referring to "our mistake." Apparently your own invisibility is the real problem causing her confusion. This is how the apparatus she propels you into begins to multiply its meaning.

What did you say?

At the end of a brief phone conversation, you tell the manager you are speaking with that you will come by his office to sign the form. When you arrive and announce yourself, he blurts out, I didn't know you were black!

I didn't mean to say that, he then says.

Aloud, you say.

What? he asks.

You didn't mean to say that aloud.

Your transaction goes swiftly after that.

And when the woman with the multiple degrees says, I didn't know black women could get cancer, instinctively you take two steps back though all urgency leaves the possibility of any kind of relationship as you realize nowhere is where you will get from here.

A friend tells you he has seen a photograph of you on the Internet and he wants to know why you look so angry. You and the photographer chose the photograph he refers to because you both decided it looked the most relaxed. Do you look angry? You wouldn't have said so. Obviously this unsmiling image of you makes him uncomfortable, and he needs you to account for that.

If you were smiling, what would that tell him about your composure in his imagination?

Despite the fact that you have the same sabbatical schedule as everyone else, he says, you are always on sabbatical. You are friends so you respond, *easy*.

What do you mean?

Exactly, what do you mean?

Someone in the audience asks the man promoting his new book on humor what makes something funny. His answer is what you expect—context. After a pause he adds that if someone said something, like about someone, and you were with your friends you would probably laugh, but if they said it out in public where black people could hear what was said, you might not, probably would not. Only then do you realize you are among "the others out in public" and not among "friends."

Not long ago you are in a room where someone asks the philosopher Judith Butler what makes language hurtful. You can feel everyone lean in. Our very being exposes us to the address of another, she answers. We suffer from the condition of being addressable. Our emotional openness, she adds, is carried by our addressability. Language navigates this.

For so long you thought the ambition of racist language was to denigrate and erase you as a person. After considering Butler's remarks, you begin to understand yourself as rendered hypervisible in the face of such language acts. Language that feels hurtful is intended to exploit all the ways that you are present. Your alertness, your openness, and your desire to engage actually demand your presence, your looking up, your talking back, and, as insane as it is, saying please.

Standing outside the conference room, unseen by the two men waiting for the others to arrive, you hear one say to the other that being around black people is like watching a foreign film without translation. Because you will spend the next two hours around the round table that makes conversing easier, you consider waiting a few minutes before entering the room.

The real estate woman, who didn't fathom she could have made an appointment to show her house to you, spends much of the walk-through telling your friend, repeatedly, how comfortable she feels around her. Neither you nor your friend bothers to ask who is making her feel uncomfortable.

I DO NOT ALWAYS FEEL
COLORED I DO NOT AL
WAYS FEEL COLORED I D
O NOT ALWAYS FEEL COLO
RED I DO NOT ALWAYS
FEEL COLORED I DO NOT
ALWAYS FEEL COLORED
I DO NOT ALWAYS FEEL CO
LORED I DO NOT ALWAYS
FEEL COLORED I DO NO
T ALWAYS FEEL COLORED
I DO NOT ALWAYS FEEL CO
LORED I DO NOT ALWAY
S FEEL COLORED I DO
NOT ALWAYS FEEL COLOR
ED I DO NOT ALWAYS FEE
L COLORED I DO NOT AL
WAYS FEEL COLORED I
DO NOT ALWAYS FEEL COL
ORED I DO NOT ALWAYS
FEEL COLORED I DO NOT
ALWAYS FEEL COLORED
I DO NOT ALWAYS FEEL

I FEEL MOST COLORED
WHEN I AM THROWN A
GAINST A SHARP WHITE
BACKGROUND I FEEL MO
ST COLORED WHEN I AM
THROWN AGAINST A SHAR
P WHITE BACKGROUND I
FEEL MOST COLORED WH
EN I AM THROWN AGAIN
ST A SHARP WHITE BACK
GROUND I FEEL MOST COL
ORED WHEN I AM THROW
N AGAINST A SHARP WHI
TE BACKGROUND I FEEL
MOST COLORED WHEN I
AM THROWN AGAINST A
SHARP WHITE BACKGROU
ND I FEEL MOST COLO
RED WHEN I AM THROWN
AGAINST A SHARP WHITE
E BACKGROUND I FEEL
MOST COLORED WHEN I
AM THROWN AGAINST A

The man at the cash register wants to know if you think your card will work. If this is his routine, he didn't use it on the friend who went before you. As she picks up her bag, she looks to see what you will say. She says nothing. You want her to say something—both as witness and as a friend. She is not you; her silence says so. Because you are watching all this take place even as you participate in it, you say nothing as well. Come over here with me, your eyes say. Why on earth would she? The man behind the register returns your card and places the sandwich and Pellegrino in a bag, which you take from the counter. What is wrong with you? This question gets stuck in your dreams.

Another friend tells you you have to learn not to absorb the world. She says sometimes she can hear her own voice saying silently to whomever—you are saying this thing and I am not going to accept it. Your friend refuses to carry what doesn't belong to her.

You take in things you don't want all the time. The second you hear or see some ordinary moment, all its intended targets, all the meanings behind the retreating seconds, as far as you are able to see, come into focus. Hold up, did you just hear, did you just say, did you just see, did you just do that? Then the voice in your head silently tells you to take your foot off your throat because just getting along shouldn't be an ambition.

IV

To live through the days sometimes you moan like deer. Sometimes you sigh. The world says stop that. Another sigh. Another stop that. Moaning elicits laughter, sighing upsets. Perhaps each sigh is drawn into existence to pull in, pull under, who knows; truth be told, you could no more control those sighs than that which brings the sighs about.

The sigh is the pathway to breath; it allows breathing. That's just self-preservation. No one fabricates that. You sit down, you sigh. You stand up, you sigh. The sighing is a worrying exhale of an ache. You wouldn't call it an illness; still it is not the iteration of a free being. What else to liken yourself to but an animal, the ruminant kind?

You like to think memory goes far back though remembering was never recommended. Forget all that, the world says. The world's had a lot of practice. No one should adhere to the facts that contribute to narrative, the facts that create lives. To your mind, feelings are what create a person, something unwilling, something wild vandalizing whatever the skull holds. Those sensations form a someone. The headaches begin then. Don't wear sunglasses in the house, the world says, though they soothe, soothe sight, soothe you.

The head's ache evaporates into a state of numbness, a cave of sighs. Over the years you lose the melodrama of seeing yourself as a patient. The sighing ceases; the head-aches remain. You hold your head in your hands. You sit still. Rarely do you lie down. You ask yourself, how can I help you? A glass of water? Sunglasses? The enteric-coated tablets live in your purse next to your license. The sole action is to turn on tennis matches without the sound. Yes, and though watching tennis isn't a cure for feeling, it is a clean displacement of effort, will, and disappointment.

The world is wrong. You can't put the past behind you. It's buried in you; it's turned your flesh into its own cupboard. Not everything remembered is useful but it all comes from the world to be stored in you. Who did what to whom on which day? Who said that? She said what? What did he just do? Did she really just say that? He said what? What did she do? Did I hear what I think I heard? Did that just come out of my mouth, his mouth, your mouth? Do you remember when you sighed?

Memory is a tough place. You were there. If this is not the truth, it is also not a lie. There are benefits to being without nostalgia. Certainly nostalgia and being without nostalgia relieve the past. Sitting here, there are no memories to remember, just the ball going back and forth. Shored up by this external net, the problem is not one of a lack of memories; the problem is simply a lack, a lack before, during, and after. The chin and your cheek fit into the palm of your hand. Feeling better? The ball isn't being returned. Someone is approaching the umpire. Someone is upset now.

You fumble around for the remote to cancel mute. The player says something and the formerly professional umpire looks down from her high chair as if regarding an unreasonable child, a small animal. The commentator wonders if the player will be able to put this incident aside. No one can get behind the feeling that caused a pause in the match, not even the player trying to put her feelings behind her, dumping ball after ball into the net. Though you can retire with an injury, you can't walk away because you feel bad.

Feel good. Feel better. Move forward. Let it go. Come on. Come on. Come on. In due time the ball is going back and forth over the net. Now the sound can be turned back down. Your fingers cover your eyes, press them deep into their sockets—too much commotion, too much for a head remembering to ache. Move on. Let it go. Come on.

V

Words work as release—well-oiled doors opening and closing between intention, gesture. A pulse in a neck, the shiftiness of the hands, an unconscious blink, the conversations you have with your eyes translate everything and nothing. What will be needed, what goes unfelt, unsaid—what has been duplicated, redacted here, redacted there, altered to hide or disguise—words encoding the bodies they cover. And despite everything the body remains.

Occasionally it is interesting to think about the outburst if you would just cry out—

To know what you'll sound like is worth noting—

In the darkened moment a body given blue light, a flash-light, enters with levity, with or without assumptions, doubts, with desire, the beating heart, disappointment, with desires—

Stand where you are.

You begin to move around in search of the steps it will take before you are thrown back into your own body, back into your own need to be found.

The destination is illusory. You raise your lids. No one else is seeking.

You exhaust yourself looking into the blue light. All day blue burrows the atmosphere. What doesn't belong with you won't be seen.

You could build a world out of need or you could hold everything black and see. You give back the lack.

You hold everything black. You give yourself back until nothing's left but the dissolving blues of metaphor.

Sometimes "I" is supposed to hold what is not there until it is. Then *what is* comes apart the closer you are to it.

This makes the first person a symbol for something.

The pronoun barely holding the person together.

Someone claimed we should use our skin as wallpaper knowing we couldn't win.

You said "I" has so much power; it's insane.

And you would look past me, all gloved up, in a big coat, with fancy fur around the collar, and record a self saying, you should be scared, the first person can't pull you together.

Shit, you are reading minds, but did you try?

Tried rhyme, tried truth, tried epistolary untruth, tried and tried.

You really did. Everyone understood you to be suffering and still everyone thought you thought you were the sun— never mind our unlikeness, you too have heard the noise in your voice.

Anyway, sit down. Sit here alongside.

Exactly why we survive and can look back with furrowed brow is beyond me.

It is not something to know.

Your ill-spirited, cooked, hell on Main Street, nobody's here, broken-down, first person could be one of many definitions of being to pass on.

The past is a life sentence, a blunt instrument aimed at tomorrow.

Drag that first person out of the social death of history, then we're kin.

Kin calling out the past like a foreigner with a newly minted "fuck you."

Maybe you don't agree.

Maybe you don't think so.

Maybe you are right, you don't really have anything to confess.

Why are you standing?

Listen, you, I was creating a life study of a monumental first person, a Brahmin first person.

If you need to feel that way—still you are in here and here is nowhere.

Join me down here in nowhere.

Don't lean against the wallpaper; sit down and pull together.

Yours is a strange dream, a strange reverie.

No, it's a strange beach; each body is a strange beach, and if you let in the excess emotion you will recall the Atlantic Ocean breaking on our heads.

Yesterday called to say we were together and you were bloodshot and again the day carried you across a field of hours, deep into dawn, back to now, where you are thankful for

what faces you, the storm, this day's sigh as the day shifts its leaves, the wind, a prompt against the calm you can't digest.

Blue ceiling calling a body into the midst of azure, oceanic, as ocean blushes the blues it can't absorb, reflecting back a day

the day frays, night, not night, this fright passes through the eye crashing into you, is this you?

Yes, it's me, clear the way, then hold me clear of this that faces, the storm carrying me through dawn

not knowing whether to climb down or up into its eye— day, hearing a breath shiver, whose are you?

Guard rail, spotlight, safety lock, airbag, fire lane, slip guard, night watch, far into this day are the days this day was meant to take out of its way. An obstacle

to surrender, dusk in dawn, held open, then closing,

then opening, a red-tailed hawk, dusk at dawn, taking over blue, surveying movement, against the calm, red sky at morning,

whose are you?

In line at the drugstore it's finally your turn, and then it's not as he walks in front of you and puts his things on the counter. The cashier says, Sir, she was next. When he turns to you he is truly surprised.

Oh my God, I didn't see you.

You must be in a hurry, you offer.

No, no, no, I really didn't see you.

You wait at the bar of the restaurant for a friend, and a man, wanting to make conversation, nursing something, takes out his phone to show you a picture of his wife. You say, bridge that she is, that she is beautiful. She is, he says, beautiful and black, like you.

Leaving the day to itself, you close the door behind you and pour a bowl of cereal, then another, and would a third if you didn't interrupt yourself with the statement—you aren't hungry.

Appetite won't attach you to anything no matter how depleted you feel.

It's true.

You lean against the sink, a glass of red wine in your hand and then another, thinking in the morning you will go to the gym having slept and slept beyond the residuals of all yesterdays.

Yes, and you do go to the gym and run in place, an entire hour running, just you and

your body running off each undesired desired encounter.

VI

August 29, 2005 / Hurricane Katrina

Script for Situation video comprised of quotes collected
from CNN, created in collaboration with John Lucas

Hours later, still in the difficulty of what it is to be, just like that, inside it, standing there, maybe wading, maybe waving, standing where the deep waters of everything backed up, one said, climbing over bodies, one said, stranded on a roof, one said, trapped in the building, and in the difficulty, nobody coming and still someone saying, who could see it coming, the difficulty of that.

The fiction of the facts assumes innocence, ignorance, lack of intention, misdirection; the necessary conditions of a certain time and place.

Have you seen their faces?

Faith, not fear, she said. She'd heard that once and was trying to stamp the phrase on her mind. At the time, she couldn't speak it aloud. He wouldn't tolerate it. He was angry. Where were they? Where was anyone? This is a goddamn emergency, he said.

Then someone else said it was the classic binary between the rich and the poor, between the haves and the have-nots, between the whites and the blacks, in the difficulty of all that.

Then each house was a mumbling structure, all that water, buildings peeling apart, the yellow foam, the contaminated drawl of mildew, mold.

The missing limbs, he said, the bodies lodged in piles of rubble, dangling from rafters, lying facedown, arms out-stretched on parlor floors.

And someone said, where were the buses? And simultane-ously someone else said, FEMA said it wasn't safe to be there.

What I'm hearing, she said, which is sort of scary, is they all want to stay in Texas.

He gave me the flashlight, she said, I didn't want to turn it on. It was all black. I didn't want to shine a light on that.

We never reached out to anyone to tell our story, because there's no ending to our story, he said. Being honest with you, in my opinion, they forgot about us.

It's awful, she said, to go back home to find your own dead child. It's really sad.

And so many of the people in the arena here, you know, she said, were underprivileged anyway, so this is working very well for them.

You simply get chills every time you see these poor individuals, so many of these people almost all of them that we see, are so poor, someone else said, and they are so black.

Have you seen their faces?

Then this aestheticized distancing from Oh my God, from unbelievable, from dehydration, from overheating, from no electricity, no power, no way to communicate

we are drowning here

still in the difficulty

as if the faces in the images hold all the consequences

and the fiction of the facts assumes randomness and indeterminacy.

He said, I don't know what the water wanted. It wanted to show you no one would come.

He said, I don't know what the water wanted. As if then and now were not the same moment.

He said, I don't know what the water wanted.

Call out to them.
I don't see them.
Call out anyway.

Did you see their faces?

February 26, 2012 / In Memory of Trayvon Martin

Script for Situation video created in collaboration with
John Lucas

My brothers are notorious. They have not been to prison. They have been imprisoned. The prison is not a place you enter. It is no place. My brothers are notorious. They do regular things, like wait. On my birthday they say my name. They will never forget that we are named. What is that memory?

The days of our childhood together were steep steps into a collapsing mind. It looked like we rescued ourselves, were rescued. Then there are these days, each day of our adult lives. They will never forget our way through, these brothers, each brother, my brother, dear brother, my dearest brothers, dear heart—

Your hearts are broken. This is not a secret though there are secrets. And as yet I do not understand how my own sorrow has turned into my brothers' hearts. The hearts of my brothers are broken. If I knew another way to be, I would call up a brother, I would hear myself saying, my brother, dear brother, my dearest brothers, dear heart—

On the tip of a tongue one note following another is another path, another dawn where the pink sky is the bloodshot of struck, of sleepless, of sorry, of senseless, shush. Those years of and before me and my brothers, the years of passage, plantation, migration, of Jim Crow segregation, of poverty, inner cities, profiling, of one in three, two jobs, boy,

hey boy, each a felony, accumulate into the hours inside our lives where we are all caught hanging, the rope inside us, the tree inside us, its roots our limbs, a throat sliced through and when we open our mouth to speak, blossoms, o blossoms, no place coming out, brother, dear brother, that kind of blue. The sky is the silence of brothers all the days leading up to my call.

If I called I'd say good-bye before I broke the good-bye. I say good-bye before anyone can hang up. Don't hang up. My brother hangs up though he is there. I keep talking. The talk keeps him there. The sky is blue, kind of blue. The day is hot. Is it cold? Are you cold? It does get cool. Is it cool? Are you cool?

My brother is completed by sky. The sky is his silence. Eventually, he says, it is raining. It is raining down. It was raining. It stopped raining. It is raining down. He won't hang up. He's there, he's there but he's hung up though he is there. Good-bye, I say. I break the good-bye. I say good-bye before anyone can hang up, don't hang up. Wait with me. Wait with me though the waiting might be the call of good-byes.

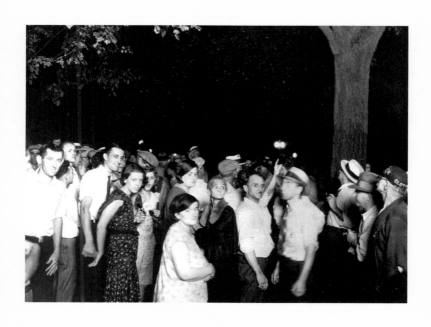

June 26, 2011 / In Memory of James Craig Anderson

Script for Situation video created in collaboration with
John Lucas

In the next frame the pickup truck is in motion. Its motion activates its darkness. The pickup truck is a condition of darkness in motion. It makes a dark subject. You mean a black subject. No, a black object.

Then the pickup is beating the black object to the ground and the tire marks the crushed organs. Then the audio, I ran that nigger over, is itself a record-breaking hot June day in the twenty-first century.

The pickup returns us to live cruelty, like sunrise, red streaks falling from dawn to asphalt—then again this pickup is not about beauty. It's a pure product.

The announcer patronizes the pickup truck, no hoodlums, "just teens," no gang, "just a teen," "with straggly blond hair," "a slight blond man." The pickup is human in this predictable way. Do you recognize yourself, Dedmon?

In the circulating photo you are looking down. Were you dreaming of this day all the days of your youth? In the daydream did the pickup take you home? Was it a pickup fueling the road to I ran that nigger over?

Baldwin says skin color cannot be more important than the human being. And was the pickup constructing or exploding whiteness out of you? You are so sorry. You are angry, an explosive anger, an effective one: I ran that nigger over.

James Craig Anderson is dead. The pickup truck is a figure of speech. It is as the crown standing in for the kingdom. Who told you it was a crown? Did we tell you the pickup was as good as home? You are so young, Dedmon. You were so young.

James Craig Anderson is dead. What ails you, Dedmon? What up? What's up is James Craig Anderson is dead. So sorry. So angry, an imploding anger. It must let you go. It let you go.

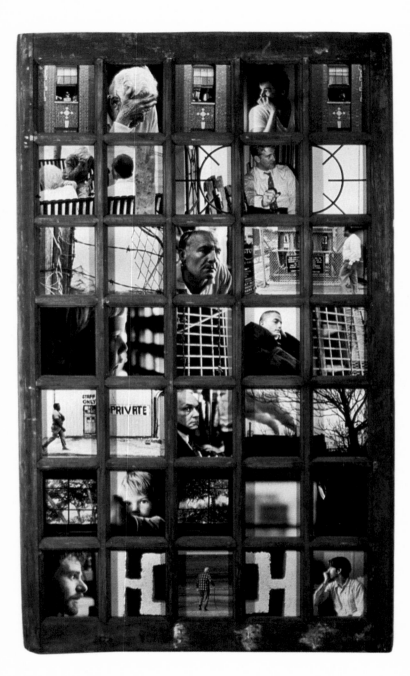

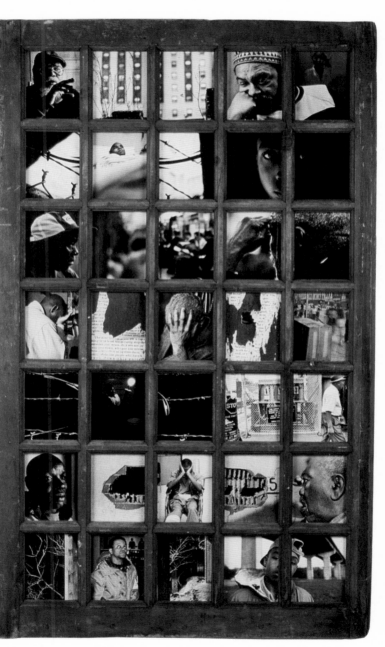

December 4, 2006 / Jena Six

Script for Situation video created in collaboration with
John Lucas

As he walked across grass still green from summer walking out of the rain a step beyond into a piece of sky dry all day for him in this moment a shelter as he sat beneath the overhanging branches of the "white tree" surprising himself at the center of the school yard thinking of the slight give in the cushions of the counter seats he had read about in textbooks did the hardness of the ground cross the hardness of the seats in buses as he waited to be noticed listening to the lift and fall of the leaves above him?

As the boys walked across grass a darkening wave as dusk folded into night walking toward a dawn sun punching through the blackness as they noosed the rope looped around the overhanging branches of their tree surprising themselves at the center of the school yard thinking this is how they will learn the ropes did the hardness in the history books cross the hardness in their eyes all the eyes with that look without give did they give that look to the lift and fall of the leaves above them?

At the high school party the boy turned to the boys as boys do walking into a fist punching through the blackness as glass shattered light knocked conscious blunt breathing bruising the refusing boy surrounded by blows taking custody of his body bodying forth against a boyhood defining it by fighting through this body propelled forward and back bearing until the beer bottle shattered hardness bruising the refusal leveled without give.

When the boys turned the corner was inflammation in the air already forming knuckles as they pummeled the body being kicked and beaten until knocked unconscious his right eye closed shut blood refusing to clot flowing from both ears were they hearing their own breathing their own ears allowing their blows to take custody of this body fallen against the hardness of the concrete floor leveled without give?

Boys will be boys being boys feeling their capacity heaving butting heads righting their wrongs in the violence of aggravated adolescence charging forward in their way experiencing the position of positioning which is a position for only one kind of boy face it know it for the other boy for the other boys the fists the feet criminalized already are weapons already exploding the landscape and then the litigious hitting back is life imprisoned.

BLUE

BLAC

BOY

Stop-and-Frisk

Script for Situation video created in collaboration with
John Lucas

I knew whatever was in front of me was happening and then the police vehicle came to a screeching halt in front of me like they were setting up a blockade. Everywhere were flashes, a siren sounding and a stretched-out roar. Get on the ground. Get on the ground now. Then I just knew.

And you are not the guy and still you fit the description because there is only one guy who is always the guy fitting the description.

I left my client's house knowing I would be pulled over. I knew. I just knew. I opened my briefcase on the passenger seat, just so they could see. Yes officer rolled around on my tongue, which grew out of a bell that could never ring because its emergency was a tolling I was meant to swallow.

In a landscape drawn from an ocean bed, you can't drive yourself sane—so angry you are crying. You can't drive yourself sane. This motion wears a guy out. Our motion is wearing you out and still you are not that guy.

Then flashes, a siren, a stretched-out roar—and you are not the guy and still you fit the description because there is only one guy who is always the guy fitting the description.

Get on the ground. Get on the ground now. I must have been speeding. No, you weren't speeding. I wasn't speeding? You didn't do anything wrong. Then why are you pulling me over? Why am I pulled over? Put your hands where they can be seen. Put your hands in the air. Put your hands up.

Then you are stretched out on the hood. Then cuffed. Get on the ground now.

Each time it begins in the same way, it doesn't begin the same way, each time it begins it's the same. Flashes, a siren, the stretched-out roar—

Maybe because home was a hood the officer could not afford, not that a reason was needed, I was pulled out of my vehicle a block from my door, handcuffed and pushed into the police vehicle's backseat, the officer's knee pressing into my collarbone, the officer's warm breath vacating a face creased into the smile of its own private joke.

Each time it begins in the same way, it doesn't begin the same way, each time it begins it's the same.

Go ahead hit me motherfucker fled my lips and the officer did not need to hit me, the officer did not need anything from me except the look on my face on the drive across town. You can't drive yourself sane. You are not insane. Our motion is wearing you out. You are not the guy.

This is what it looks like. You know this is wrong. This is not what it looks like. You need to be quiet. This is wrong. You need to close your mouth now. This is what it looks like. Why are you talking if you haven't done anything wrong?

And you are not the guy and still you fit the description because there is only one guy who is always the guy fitting the description.

In a landscape drawn from an ocean bed, you can't drive yourself sane—so angry you can't drive yourself sane.

The charge the officer decided on was exhibition of speed. I was told, after the fingerprinting, to stand naked. I stood naked. It was only then I was instructed to dress, to leave, to walk all those miles back home.

And still you are not the guy and still you fit the description because there is only one guy who is always the guy fitting the description.

And yes, the inaudible spreads across state lines.

Its call backing away from the face of America.

Bloodshot eyes calling on America

that can't look forward for being called back.

America turned loose on America—

All living is listening for a throat to open—

The length of its silence shaping lives.

When he opened his mouth to speak, his speech
was what was written in the silence,

the length of the silence becoming a living.

And what had been

"I do solemnly swear that I will faithfully

execute the office of President of the United States . . ."

becomes

"I do solemnly swear that I will execute

the office of President to the United States faithfully . . ."

August 4, 2011 / In Memory of Mark Duggan

Though this house in London has been remodeled, the stairs, despite being carpeted, creak. What was imagined as a silent retreat from the party seems to sound through the house. By the fifth step you decide to sit down and on the wall next to you is a torn passport photo of half a woman's face blown up and framed as art. Where did you imagine you were going? you say aloud to her.

"The purpose of art," James Baldwin wrote, "is to lay bare the questions hidden by the answers." He might have been channeling Dostoyevsky's statement that "we have all the answers. It is the questions we do not know."

Where can I imagine you have been?

A man, a novelist with the face of the English sky—full of weather, always in response, constantly shifting, clouding over only to clear briefly—stands before you, his head leaning against the same wall as the torn-up girl. You begin discussing the recent riots in Hackney. Despite what is being said you get lost in his face, his responsiveness bringing what reads as intimacy to his eyes. He says the riots were similar to the Rodney King–LA riots; however, he feels the UK media handled them very differently from the US media.

The Hackney riots began at the end of the summer of 2011 when Mark Duggan, a black man, a husband, a father, and

a suspected drug dealer, was shot dead by officers from Scotland Yard's Operation Trident (a special operations unit addressing gun crime in black communities). As the rioting and looting continued, government officials labeled the violent outbreak "opportunism" and "sheer criminality," and the media picked up this language. Whatever the reason for the riots, images of the looters' continued rampage eventually displaced the fact that an unarmed man was shot to death.

In the United States, Rodney King's beating, caught on video, trumped all other images. If there had been a video of Duggan being executed, there might be less ambiguity around what started the riots, you hazard to say.

Will you write about Duggan? the man wants to know. Why don't you? you ask. Me? he asks, looking slightly irritated.

How difficult is it for one body to feel the injustice wheeled at another? Are the tensions, the recognitions, the disappointments, and the failures that exploded in the riots too foreign?

A similar accumulation and release drove many Americans to respond to the Rodney King beating. Before it happened, it had happened and happened. As a black body in the States, your response was necessary if you were to hold on

to the fiction that this was an event "wrongfully ordinary," therefore a snafu within the ordinary.

Though the moment had occurred and occurred again with the deaths, beatings, and imprisonment of other random, unarmed black men, Rodney King's beating somehow cut off the air supply in the US body politic by virtue of the excessive, blatant barrage of racism and compromised justice that followed on the heels of his beating. And though in this man's body, the man made of English sky, grief exists for Duggan as a black man gunned down, there is not the urgency brought on by an overflow of compromises, deaths, and tempers specific to a profile woke to and gone to sleep to each day.

Arguably, there is no simultaneity between the English sky and the body being ordered to rest in peace. This difference, which has to do with "the war (the black body's) presence has occasioned," to quote Baldwin, makes all the difference. One could become acquainted with the inflammation that existed around Duggan's body and it would be uncomfortable. Grief comes out of relationships to subjects over time and not to any subject in theory, you tell the English sky, to give him an out. The distance between you and him is thrown into relief: bodies moving through the same life differently. With your eyes wide open you consider what this man and you, two middle-aged artists,

in a house worth more than a million pounds, share with Duggan. Mark Duggan, you are part of the misery. Apparently your new friend won't write about Mark Duggan or the London riots; still you continue searching his face because there is something to find, an answer to question.

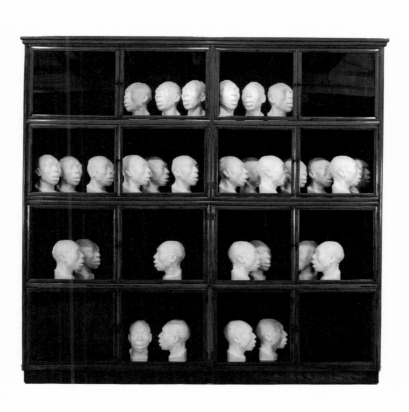

October 10, 2006 / World Cup

Script for Situation video created in collaboration with
John Lucas

LANC-BEUR

Something is there before us that is neither the living person himself nor any sort of reality, neither the same as the one who is alive, nor another.

What is there is the absolute calm of what has found its place.

Every day I think about where I came from and I am still proud to be who I am . . .

Big Algerian shit, dirty terrorist, nigger.

Perhaps the most insidious and least understood form of segregation is that of the word.

The Algerian men, for their part, are a target of criticism for their European comrades.

Arise directly to the level of tragedy.

Notice too, illustrations of this kind of racial prejudice can be multiplied indefinitely.

Clearly, the Algerians who, in view of the intensity of the repression and the frenzied character of the oppression,

Maurice Blanchot

Zinedine Zidane

Accounts of lip readers responding to the transcript of the World Cup.

Ralph Ellison

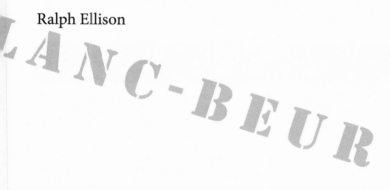

thought they could answer the blows received without any serious problem of conscience.

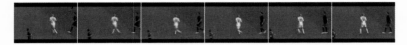

And there is no (Black) who has not felt, briefly or for long periods, with anguish sharp or dull, in varying degrees and to varying effect, simple, naked, and unanswerable hatred; who has not wanted to smash any white face he may encounter in a day, to violate, out of motives of the cruelest vengeance . . . to break the bodies of all white people and bring them low, as low as the dust into which he himself has been and is being trampled; no black who has not had to make his own precarious adjustment . . . yet the adjustment must be made—rather it must be attempted.

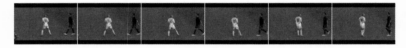

Do you think two minutes from the end of a World Cup final, two minutes from the end of my career, I wanted to do that?

Each decision gave rise to the same hesitations, produced the same despair.

No one is free.

For all that he is, people will say he remains for us an Arab. "You can't get away from nature."

Frantz Fanon

James Baldwin

Zinedine Zidane

Frantz Fanon

Big Algerian shit, dirty terrorist.

Let him do his spite: My services which I have done . . .
Shall out-tongue his complaints.

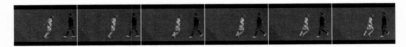

When such things happen, he must grit his teeth, walk
away a few steps, elude the passerby who draws attention
to him, who gives other passersby the desire either to follow
the example or to come to his defense.

Big Algerian shit, dirty terrorist, nigger.

That man who is forced each day to snatch his manhood,
his identity, out of the fire of human cruelty that rages to
destroy it, knows . . . something about himself and human
life that no school on earth—and indeed, no church—can
teach. He achieves his own authority, and that is unshakable.

This is because, in order to save his life, he is forced to look
beneath appearances, to take nothing for granted, to hear
the meaning behind the words.

We hear, then we remember.

The state of emergency is also always a state of emergence.

Accounts of lip readers responding to the transcript of the World Cup.

William Shakespeare

Frantz Fanon

Accounts of lip readers responding to the transcript of the World Cup.

James Baldwin

Homi Bhabha

But at this moment—from whence came the spirit I don't know—I resolved to fight; and, suiting my action to the resolution . . .

What we have here is not the bringing to light of a character known and frequented a thousand times in the imagination or in stories.

It is the White Man who creates the black man. But it is the black man who creates.

This thing was there, we grasped it in the living motion.

What he said "touched the deepest part of me."

The rebuttal assumes an original form.

This endless struggle to achieve and reveal and confirm a human identity, human authority, contains, for all its horror, something very beautiful.

Frederick Douglass

Frantz Fanon

Maurice Blanchot

Zinedine Zidane

James Baldwin

July 29 – August 18, 2014 / Making Room

Script for Public Fiction at Hammer Museum

On the train the woman standing makes you understand there are no seats available. And, in fact, there is one. Is the woman getting off at the next stop? No, she would rather stand all the way to Union Station.

The space next to the man is the pause in a conversation you are suddenly rushing to fill. You step quickly over the woman's fear, a fear she shares. You let her have it.

The man doesn't acknowledge you as you sit down because the man knows more about the unoccupied seat than you do. For him, you imagine, it is more like breath than wonder; he has had to think about it so much you wouldn't call it thought.

When another passenger leaves his seat and the standing woman sits, you glance over at the man. He is gazing out the window into what looks like darkness.

You sit next to the man on the train, bus, in the plane, waiting room, anywhere he could be forsaken. You put your body there in proximity to, adjacent to, alongside, within.

You don't speak unless you are spoken to and your body speaks to the space you fill and you keep trying to fill it except the space belongs to the body of the man next to you, not to you.

Where he goes the space follows him. If the man left his seat before Union Station you would simply be a person in a seat on the train. You would cease to struggle against the unoccupied seat when where why the space won't lose its meaning.

You imagine if the man spoke to you he would say, it's okay, I'm okay, you don't need to sit here. You don't need to sit and you sit and look past him into the darkness the train is moving through. A tunnel.

All the while the darkness allows you to look at him. Does he feel you looking at him? You suspect so. What does suspicion mean? What does suspicion do?

The soft gray-green of your cotton coat touches the sleeve of him. You are shoulder to shoulder though standing you could feel shadowed. You sit to repair whom who? You erase that thought. And it might be too late for that.

It might forever be too late or too early. The train moves too fast for your eyes to adjust to anything beyond the man, the window, the tiled tunnel, its slick darkness. Occasionally, a white light flickers by like a displaced sound.

From across the aisle tracks room harbor world a woman asks a man in the rows ahead if he would mind switching

seats. She wishes to sit with her daughter or son. You hear but you don't hear. You can't see.

It's then the man next to you turns to you. And as if from inside your own head you agree that if anyone asks you to move, you'll tell them we are traveling as a family.

In Memory of Jordan Russell Davis
In Memory of Eric Garner
In Memory of John Crawford
In Memory of Michael Brown
In Memory of Akai Gurley
In Memory of Tamir Rice
In Memory of Walter Scott
In Memory of Freddie Gray Jr.
In Memory of Sharonda Coleman-Singleton
In Memory of Cynthia Hurd
In Memory of Susie Jackson
In Memory of Ethel Lee Lance
In Memory of DePayne Middleton Doctor
In Memory of Clementa Pinckney
In Memory of Tywanza Sanders
In Memory of Daniel L. Simmons, Sr.
In Memory of Myra Thompson
In Memory of Sandra Bland
In Memory
In Memory
In Memory
In Memory
In Memory
In Memory
In Memory
In Memory
In Memory
In Memory

because white men can't
police their imagination
black men are dying

VII

Some years there exists a wanting to escape—

you, floating above your certain ache—

still the ache coexists.

Call that the immanent you—

You are you even before you

grow into understanding you

are not anyone, worthless,

not worth you.

Even as your own weight insists
you are here, fighting off
the weight of nonexistence.

And still this life parts your lids, you see
you seeing your extending hand

as a falling wave—

I they he she we you turn
only to discover
the encounter

to be alien to this place.

Wait.

The patience is in the living. Time opens out to you.

The opening, between you and you, occupied,
zoned for an encounter,

given the histories of you and you—

And always, who is this you?

The start of you, each day,
a presence already—

Hey you—

Slipping down burying the you buried within. You are everywhere and you are nowhere in the day.

The outside comes in—

Then you, hey you—

Overheard in the moonlight.

Overcome in the moonlight.

Soon you are sitting around, publicly listening, when you hear this—what happens to you doesn't belong to you, only half concerns you. He is speaking of the legionnaires in Claire Denis's film *Beau Travail* and you are pulled back into the body of you receiving the nothing gaze—

The world out there insisting on this only half concerns you. What happens to you doesn't belong to you, only half concerns you. It's not yours. Not yours only.

And still a world begins its furious erasure—

Who do you think you are, saying I to me?

You nothing.

You nobody.

You.

A body in the world drowns in it—

Hey you—

All our fevered history won't instill insight,
won't turn a body conscious,
won't make that look
in the eyes say yes, though there is nothing

to solve

even as each moment is an answer.

Don't say I if it means so little,
holds the little forming no one.

You are not sick, you are injured—

you ache for the rest of life.

How to care for the injured body,

the kind of body that can't hold
the content it is living?

And where is the safest place when that place
must be someplace other than in the body?

Even now your voice entangles this mouth
whose words are here as pulse, strumming
shut out, shut in, shut up—

You cannot say—

A body translates its you—

you there, hey you

even as it loses the location of its mouth.

When you lay your body in the body
entered as if skin and bone were public places,

when you lay your body in the body
entered as if you're the ground you walk on,

you know no memory should live
in these memories

becoming the body of you.

You slow all existence down with your call
detectable only as sky. The night's yawn
absorbs you as you lie down at the wrong angle

to the sun ready already to let go of your hand.

Wait with me
though the waiting, wait up,
might take until nothing whatsoever was done.

To be left, not alone, the only wish—

to call you out, to call out you.

Who shouted, you? You

shouted you, you the murmur in the air, you sometimes
sounding like you, you sometimes saying you,

go nowhere,

be no one but you first—

Nobody notices, only you've known,

you're not sick, not crazy,
not angry, not sad—

It's just this, you're injured.

Everything shaded everything darkened everything shadowed

is the stripped is the struck—

is the trace
is the aftertaste.

I they he she we you were too concluded yesterday to know whatever was done could also be done, was also done, was never done—

The worst injury is feeling you don't belong so much

to you—

When the waitress hands your friend the card she took from you, you laugh and ask what else her privilege gets her? Oh, my perfect life, she answers. Then you both are laughing so hard, everyone in the restaurant smiles.

Closed to traffic, the previously unexpressive street fills with small bodies. One father, having let go of his child's hand, stands on the steps of a building and watches. You can't tell which child is his, though you follow his gaze. It seems to belong to all the children as it envelops their play. You were about to enter your building, but do not want to leave the scope of his vigilance.

July 13, 2013

A friend writes of the numbing effects of humming and it returns you to your own sigh. It's no longer audible. You've grown into it. Some call it aging—an internalized liquid smoke blurring ordinary ache.

Just this morning another, What did he say?

Come on, get back in the car. Your partner wants to face off with a mouth and who knows what handheld objects the other vehicle carries.

Trayvon Martin's name sounds from the car radio a dozen times each half hour. You pull your love back into the seat because though no one seems to be chasing you, the justice system has other plans.

Yes, and this is how you are a citizen: Come on. Let it go. Move on.

Despite the air-conditioning you pull the button back and the window slides down into its door-sleeve. A breeze touches your cheek. As something should.

What feels more than feeling? You are afraid there is something you are missing, something obvious. A feeling that feelings might be irrelevant if they point to one's irrelevance pulls at you.

Do feelings lose their feeling if they speak to a lack of feeling? Can feelings be a hazard, a warning sign, a disturbance, distaste, the disgrace? Don't feel like you are mistaken. It's not that (Is it not that?) you are oversensitive or misunderstanding.

You know feelings destabilize since everyone you ask is laughing that kind of close-the-gap laughter: all the ha-ha's wanting uninterrupted views. Don't be ridiculous. None of the other black friends feel that way and how you feel is how you feel even if what you perceive isn't tied to what is . . .

What is?

And so it goes until the vista includes only displacement of feeling back into the body, which gave birth to the feelings that don't sit comfortably inside the communal.

You smile dumbly at the world because you are still feeling if only the feeling could be known and this brings on the moment you recognize as desire.

Every day your mouth opens and receives the kiss the world offers, which seals you shut though you are feeling sick to your stomach about the beginning of the feeling that was born from understanding and now stumbles around in you—the go-along-to-get-along tongue pushing your tongue aside. Yes, and your mouth is full up and the feeling is still tottering—

"The subject of so many films is the protection of the victim, and I think, I don't give a damn about those things. It's not the job of films to nurse people. With what's happening in the chemistry of love, I don't want to be a nurse or a doctor, I just want to be an observer."

As a child, Claire Denis wished to be a nurse; she is no longer a child. Years have passed and so soon we love this world, so soon we are willing to coexist with dust in our eyes.

And, of course, you want the days to add up to something more than you came in out of the sun and drank the potable water of your developed world—

yes, and because words hang in the air like pollen, the throat closes. You hack away.

That time and that time and that time the outside blistered the inside of you, words outmaneuvered years, had you in a chokehold, every part roughed up, the eyes dripping.

That's the bruise the ice in the heart was meant to ice.

To arrive like this every day for it to be like this to have so many memories and no other memory than these for as long as they can be remembered to remember this.

Though a share of all remembering, a measure of all memory, is breath and to breathe you have to create a truce—

a truce with the patience of a stethoscope.

I can hear the even breathing that creates passages to dreams. And yes, I want to interrupt to tell him her us you me I don't know how to end what doesn't have an ending.

Tell me a story, he says, wrapping his arms around me.

Yesterday, I begin, I was waiting in the car for time to pass. A woman pulled in and started to park her car facing mine. Our eyes met and what passed passed as quickly as the look away. She backed up and parked on the other side of the lot. I could have followed her to worry my question but I had to go, I was expected on court, I grabbed my racket.

The sunrise is slow and cloudy, dragging the light in, but barely.

Did you win? he asks.

It wasn't a match, I say. It was a lesson.

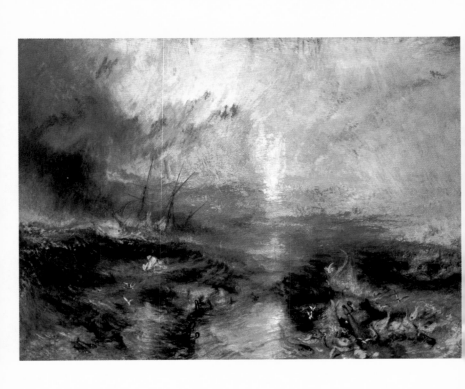

Images

historical context. New political and psychological associations emerge in the black-and-white presentation that covers the walls.

Pages 86–87
Toyin Odutola
Title: *Uncertain, yet Reserved. (Adeola. Abuja Airport, Nigeria.),* 2012 pen ink and acrylic ink on board 20 x 30 inches 29½ x 39½ x 1½ inches framed

Page 91
Hulton Archives
Title: *Public Lynching*
Date: August 30, 1930
Credit: Getty Images
(Image alteration with permission: John Lucas)

Pages 96–97
John Lucas
Title: *Male II & I,* 1996
gelatin silver prints and found objects 72 x 60 inches

Pages 102–103
Carrie Mae Weems
Title: *Blue Black Boy,* 1997
From the series "Colored People"
silver print with text on mat 30 x 30 inches

Pages 110–111
Glenn Ligon
Title: *Untitled (speech/crowd) #2,* 2000

(Detail) silkscreen, coal dust, oilstick, glue on paper, 40 x 54 inches (101.6 x 137.2 cm)

Page 119
Radcliffe Bailey
Title: *Cerebral Caverns,* 2011
wood, glass, and 30 plaster heads 97 x 100 x 60 inches

Pages 122–128
John Lucas
ABC NEWS IMAGE

Page 147
Wangechi Mutu
Title: *Sleeping Heads,* 2006
mixed media, collage on Mylar; "wounded wall": punctured latex. Set of 8: Approx. 17 x 22 inches (43.2 x 55.9 cm) each. Wall installation done on site. Courtesy of the artist and Susanne Vielmetter, Los Angeles Projects, The Pinnell Collection

Page 160
Joseph Mallord William Turner
Title: *The Slave Ship,* circa 1840
oil on canvas, © Burstein Collection CORBIS

Page 161
Joseph Mallord William Turner
Detail of Fish Attacking Slave from *The Slave Ship,* © Burstein Collection/ CORBIS

Works Referenced

Baldwin, James. *The Fire Next Time*. New York: Laurel-Dell, 1962.

———. *Notes of a Native Son*. New York: Dial Press, 1963.

Berlant, Lauren. *Cruel Optimism*. Durham, NC: Duke University Press, 2011.

Berryman, John. *The Dream Songs*. New York: Farrar, Straus and Giroux, 1969.

Bhabha, Homi K. *The Location of Culture*. London and New York: Routledge, 1994.

Blanchot, Maurice. *The Space of Literature*. Trans. Ann Smock. Lincoln: University of Nebraska Press, 1982.

Douglass, Frederick. *Narrative of the Life of Frederick Douglass, an American Slave*. 1845. Reprint, New York: Penguin Books, 1986.

Ellison, Ralph. *Invisible Man*. New York: Random House, 1992.

Fanon, Frantz. *The Wretched of the Earth*. New York: Grove Press, 1963.

———. *A Dying Colonialism*. New York: Grove Press, 1965.

Hammons, David. *Concerto in Black and Blue* (mixed media), 2002.

Lee, Kevin. http://mubi.com/notebook/posts/spectacularly-intimate-an-interview-with-claire-denis. Published on April 2, 2009.

Lowell, Robert. *Life Studies*. New York: Farrar, Straus and Giroux, 1959.

———. *For the Union Dead*. New York: Farrar, Straus and Giroux, 1964.

Shakespeare, William. *The Tragedy of Othello, the Moor of Venice*. New York: Washington Square Press, 1993.

Williams, Patricia. *The Alchemy of Race and Rights: The Diary of a Law Professor*. Cambridge, MA: Harvard University Press, 1991.

Youngman, Hennessy/Musson, Jayson

http://www.youtube.com/watch?v=3L_NnX8oj-g&list=UU1kdURWGVjuksaqGK3oGoxA

http://www.youtube.com/watch?v=hNXLoSYJ2eU&list=UU1kdURWGVjuksaqGK3oGoxA

Zidane, Zinedine: http://www.guardian.co.uk/football/2004/apr/04/sport.features

Grateful acknowledgment is made to the editors of the publications in which poems and essays from this book first appeared: *Blackbird, Boston Review, Lana Turner, Ploughshares, Poetry, Poets Writing Across Borders: The Strangest of Theatres,* and *Pushcart Prize XXXVIII: Best of the Small Presses.*

Immeasurable gratitude to Elizabeth Alexander, Catherine Barnett, Calvin Bedient, Lauren Berlant, Mei-mei Berssenbrugge, Sarah Blake, Jericho Brown, Prudence Carter, Jeff Clark, Allison Coudert, Nick Flynn, Louise Glück, Hillary Gravendyk, Kate Greenstreet, Annie Guthrie, Rupert Grant, Karen Green, Marilyn Hacker, Christine Hume, Melanie Joseph, Nancy Jugan, Alex Juhasz, Bhanu Kapil, Sally Keith, Aaron Kunin, Robin Coste Lewis, Diana Linden, Casey Llewellyn, Beth Loffreda, Maggie Nelson, Lisa Pearson, Maitreyi Pesques, Nicolas Pesques, Adam Plunkett, Patricia Powell, Romarilyn Ralston, Ira Sadoff, Sarah Juliette Sasson, Sarah Schulman, Lisa Sewell, Connie Rogers Tilton, Jen Tilton, Susan Wheeler, and Ronaldo Wilson.

To everyone who generously shared their stories, thank you.

Thank you also to Pomona College, UCross Foundation, and Graywolf Press. Thank you, Katie Dublinski and Jeff Shotts.

And finally, jaw-dropping gratitude to Ula and John for everything.